DOUBLE ELEPHANT
GARRY WINOGRAND

DOUBLE ELEPHANT / EDITED BY THOMAS ZANDER

DOUBLE ELEPHANT

GARRY WINOGRAND

STEIDL GALERIE THOMAS ZANDER

GARRY WINOGRAND

"The fact is the sweetest dream that labor knows."
Robert Frost

Understanding Still Photographs

There is nothing as mysterious as a fact clearly described. What I write here is a description of what I have come to understand about photography, from photographing and from looking at photographs. A work of art is that thing whose form and content are organic to the tools and materials that made it. Still photography is a chemical, mechanical process. Literal description or the illusion of literal description, is what the tools and materials of still photography do better than any other graphic medium. A still photograph is the illusion of a literal description of how a camera saw a piece of time and space. Understanding this, one can postulate the following theorem:

Anything and all things are photographable. A photograph can only look like how the camera saw what was photographed. Or, how the camera saw the piece of time and space is responsible for how the photograph looks. Therefore, a photograph can look any way. Or, there's no way a photograph had to look (beyond being an illusion of a literal description). Or, there are no external or abstract or preconceived rules of design that can apply to still photographs. I like to think of photographing as a two-way act of respect. Respect for the medium, by letting it do what it does best, describe. And respect for the subject, by describing it as it is. A photograph must be responsible to both.

Garry Winogrand
Austin, Texas, 1974

A portfolio of fifteen photographs, published in a limited edition of seventy-five copies, plus fifteen artist's proofs. Each print has been signed and numbered by the photographer. Each photograph was printed by the photographer on G.A.F.-V.C. photographic paper. Archival processing was done by Richard M. A. Benson and John Deeks, who also mounted the photographs on a 300-pound, hand-made Fabriano Classico paper. The paper was embossed by Kathleen Caraccio and Catherine Carine of the Printmaking Workshop. The portfolio was designed by John Berg and manufactured by Brewer-Cantelmo Co., Inc. The text sheets were serigraphed by Richard Kenerson. The introductory essay was written by Garry Winogrand. The project editors were Burton Richard Wolf, Eugene Stuttman, and Lee Friedlander.

Edited by Lee Friedlander for The Double Elephant Press Ltd., 205 East 42nd Street, New York, New York, 10017.

1

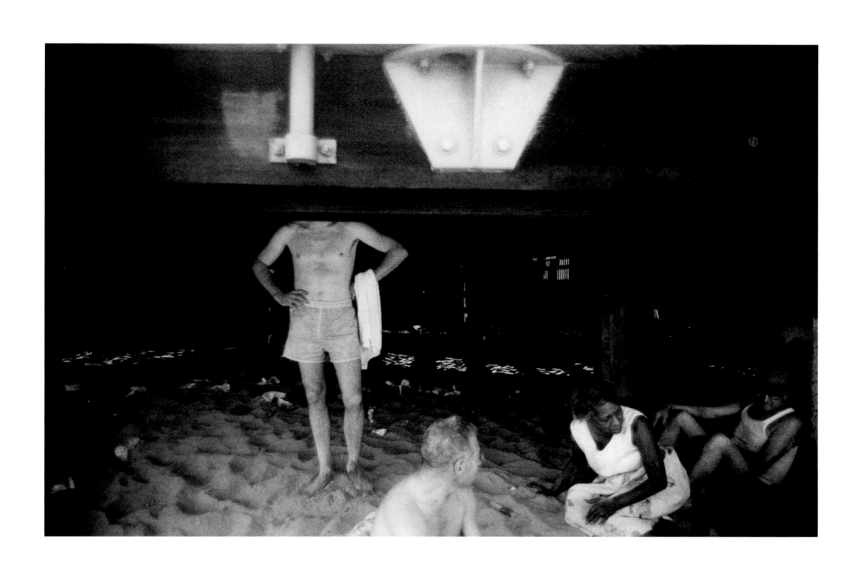

2

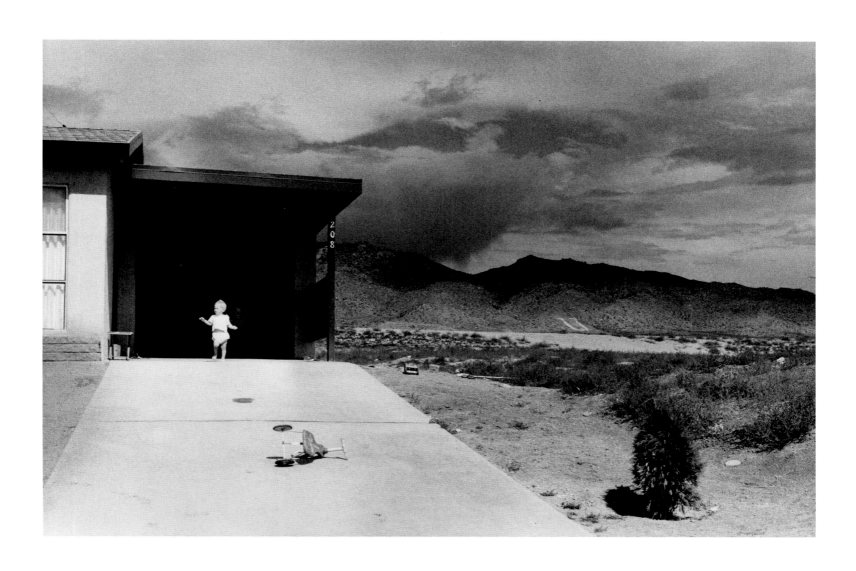

3

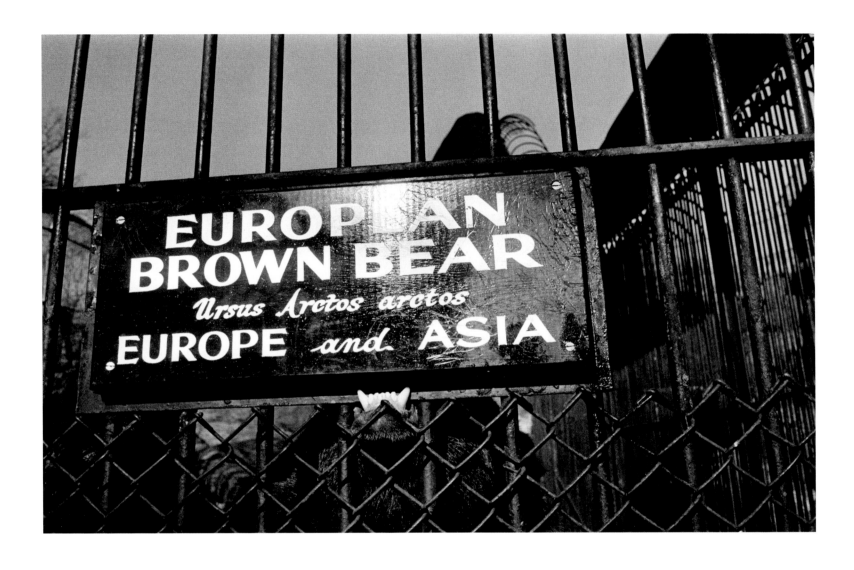

4

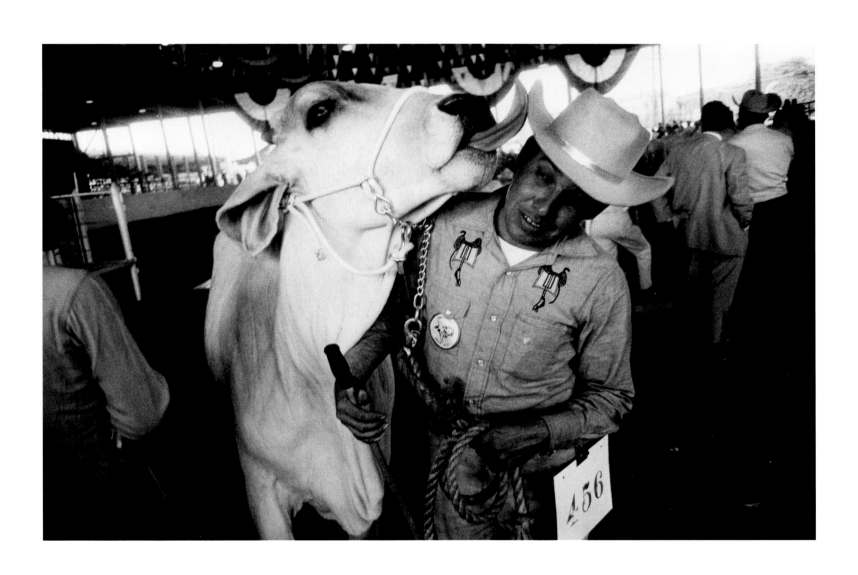

5

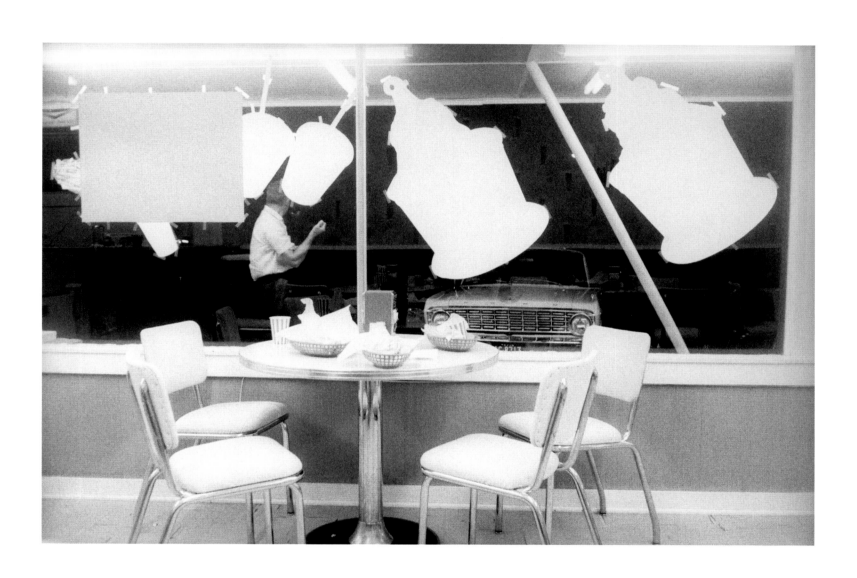

6

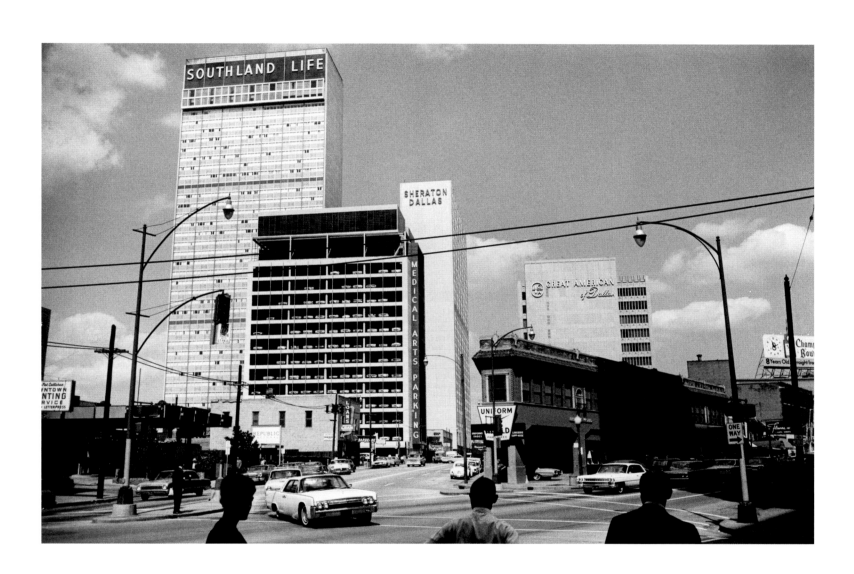

7

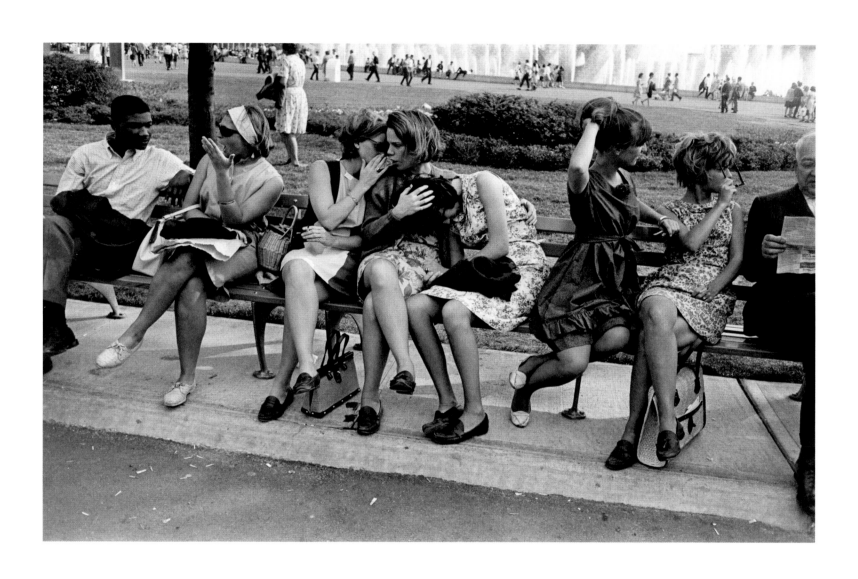

8

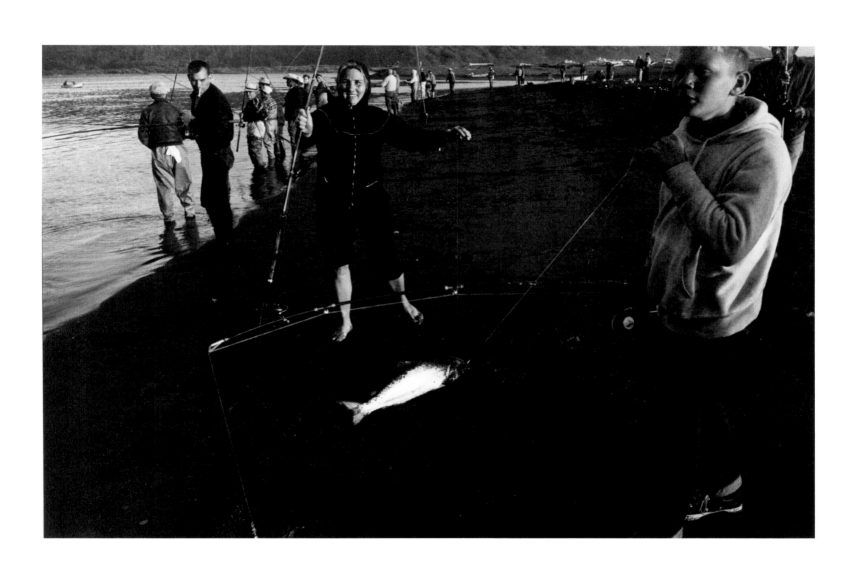

9

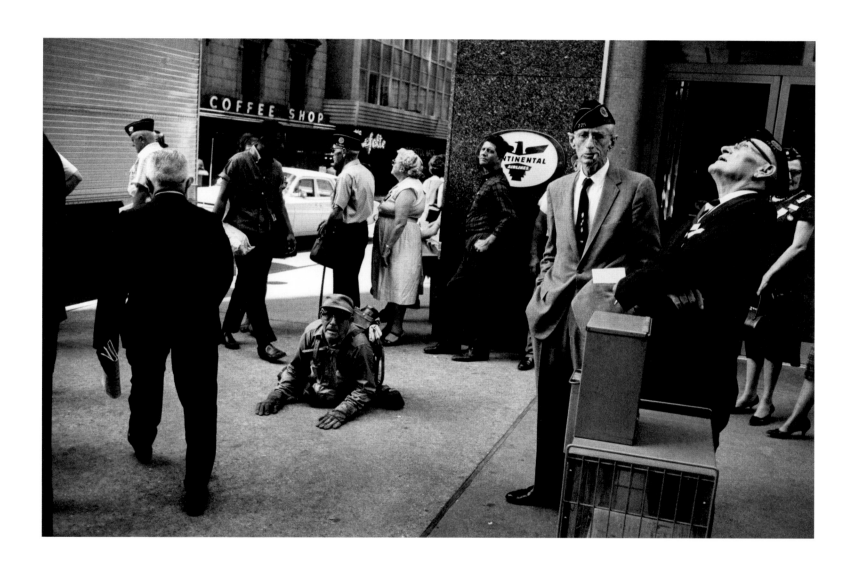

10

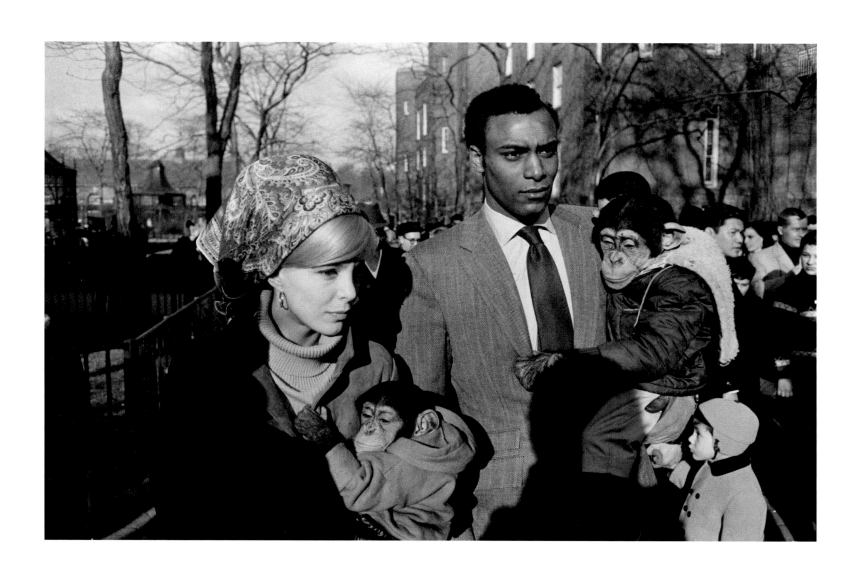

11

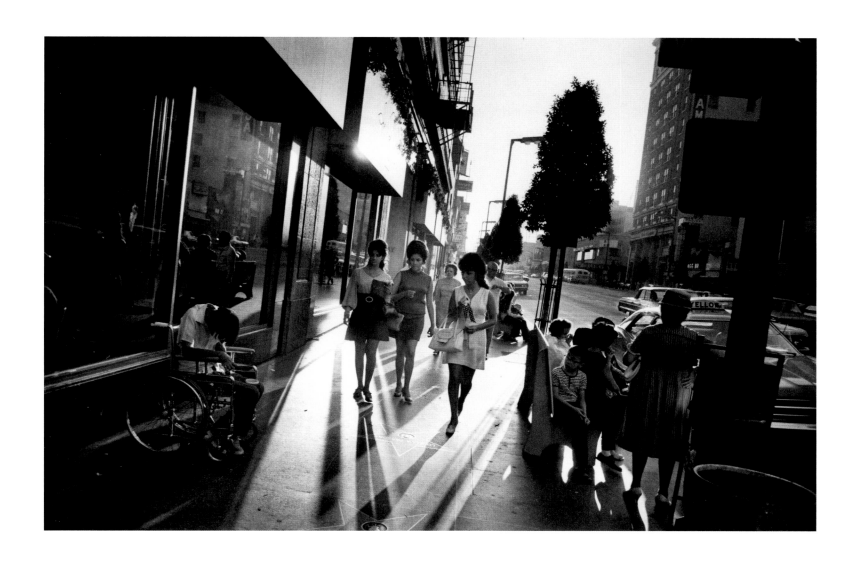

12

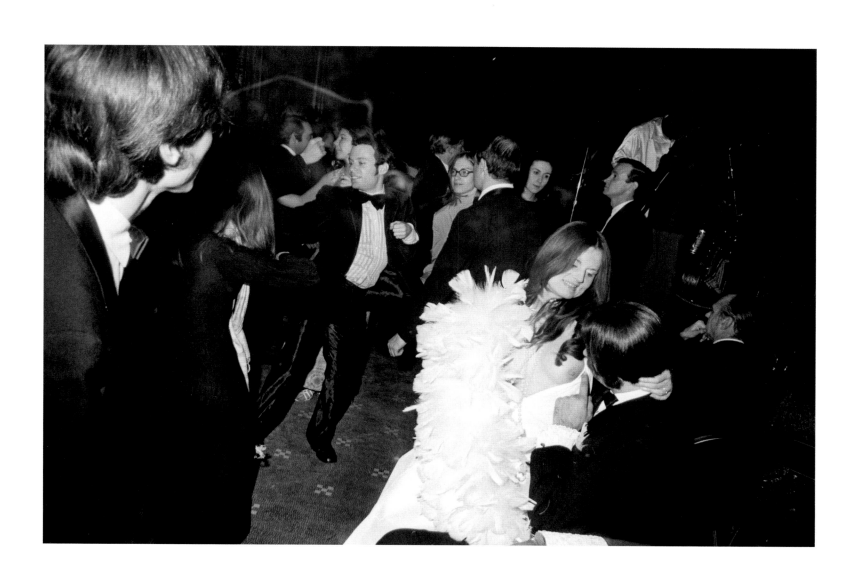

13

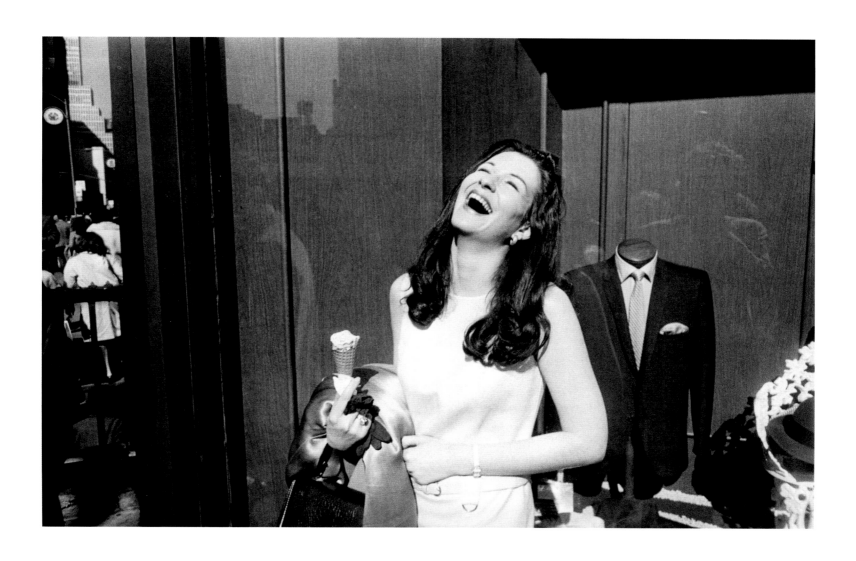

14

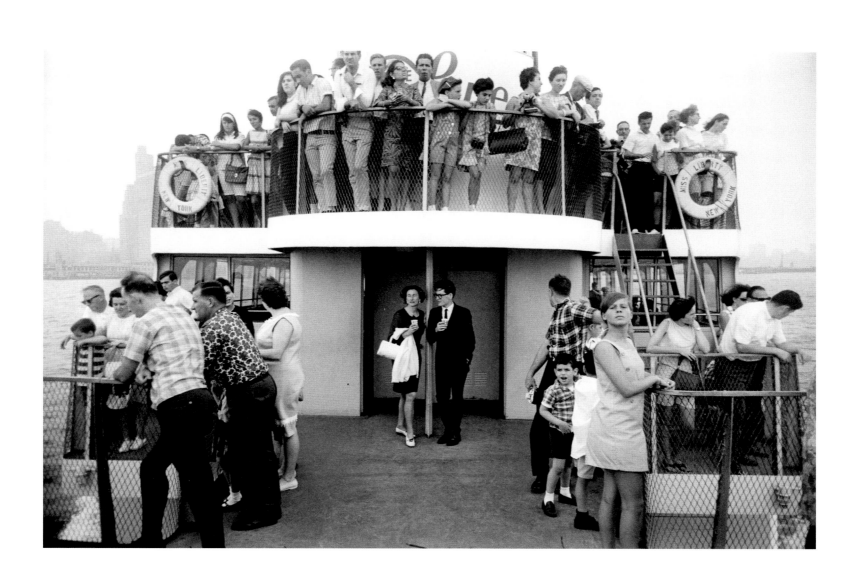

15

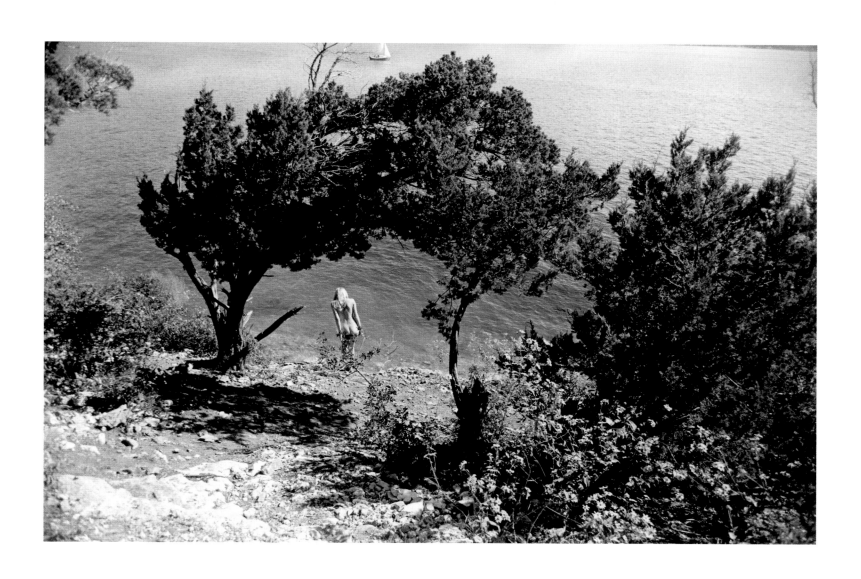

First book edition published in 2015

Image sequence, portfolio description, and introductory
text by Garry Winogrand from the original portfolio.

Editor: Thomas Zander
Project management: Frauke Breede, Anna Höfinghoff
Copyediting: Keonaona Peterson
Book design: Duncan Whyte, Bernard Fischer, Sarah Winter, Gerhard Steidl
Tritone separations by Steidl
Production and printing: Steidl, Göttingen

Steidl
Düstere Str. 4 / 37073 Göttingen, Germany
Phone +49 551 49 60 60 / Fax +49 551 49 60 649
mail@steidl.de
steidl.de

Galerie Thomas Zander
Schönhauser Str. 8 / 50968 Cologne, Germany
Phone +49 221 934 88 56 / Fax +49 221 934 88 58
mail@galeriezander.com
galeriezander.com

ISBN 978-3-86930-743-5
Printed in Germany by Steidl